AFRICAN
DESIGNS

MARTY NOBLE

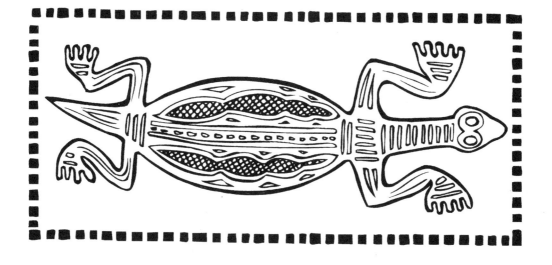

DOVER PUBLICATIONS, INC.
MINEOLA, NEW YORK

NOTE

The bold, expressive art of Africa is often inspired by the spiritual or cultural beliefs held by the many tribes and groups of the continent. Generally, each medium, process, and design holds special significance to the artist or recipient, and is carefully chosen to fulfill a certain function, as well as reflect the values of the tribe. After undergoing a lengthy period of training under an acknowledged master, artists are commissioned to craft a piece, such as a vessel or mask, that incorporates his creativity, the patron's specifications, and the tribe's standards. Often, these works will play an important role in rituals or ceremonies and will be added to the patron's religious or ancestral shrine.

Depicting motifs found in art and artifacts from groups across Africa, the designs on the following pages show the wonderful versatility and vitality of the resourceful artists. Using the natural materials found in their environment, they are able to create beautiful and distinct styles unique to their particular culture. When available, names of the groups have been included in the captions, as well as the countries and regions in which they live.

Bibliographical Note

African Designs, published by Dover Publications, Inc., in 2013, is a republication of the edition originally published by Dover in 2003. One additional plate has been added for the present edition.

International Standard Book Number

ISBN-13: 978-0-486-49309-1
ISBN-10: 0-486-49309-1

Manufactured in the United States by Courier Corporation
49309101 2013
www.doverpublications.com

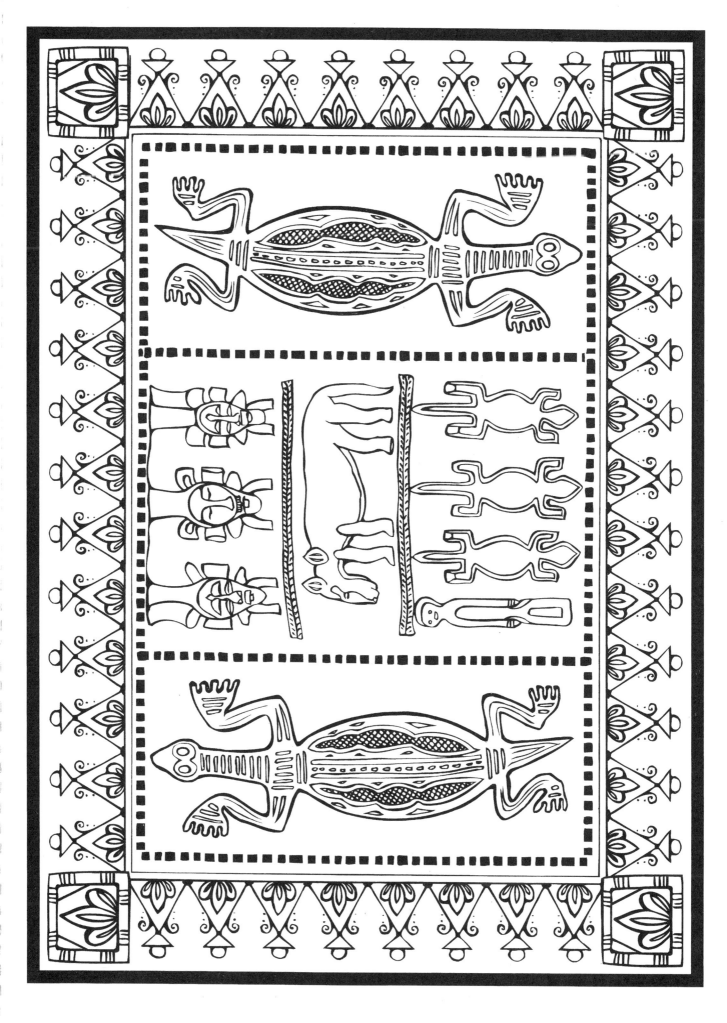

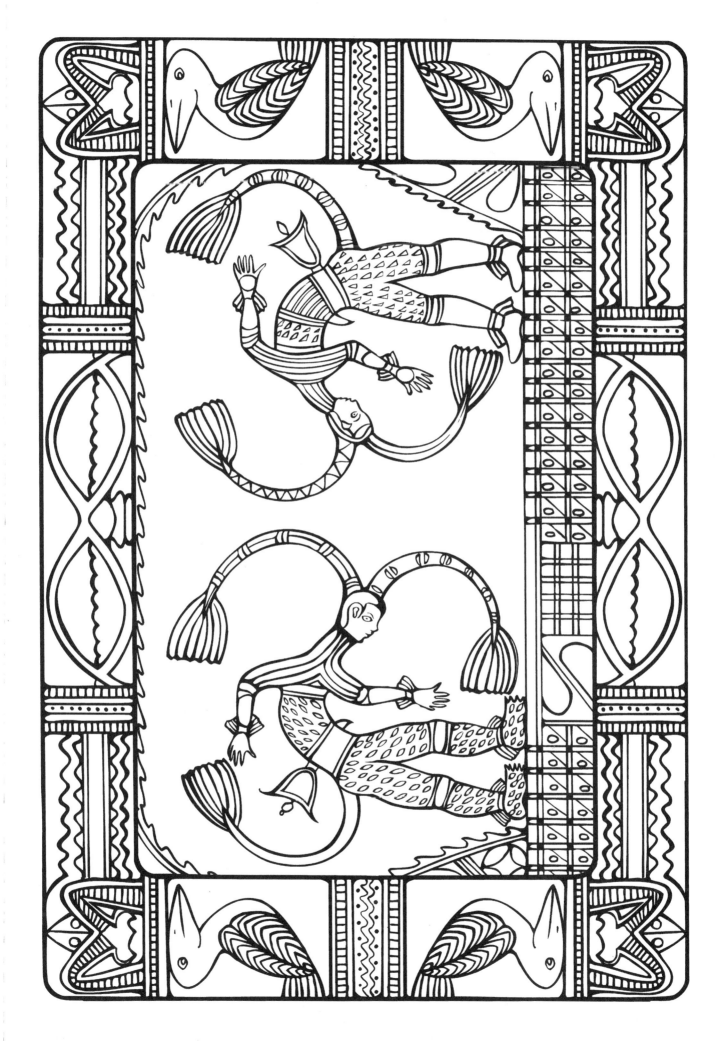

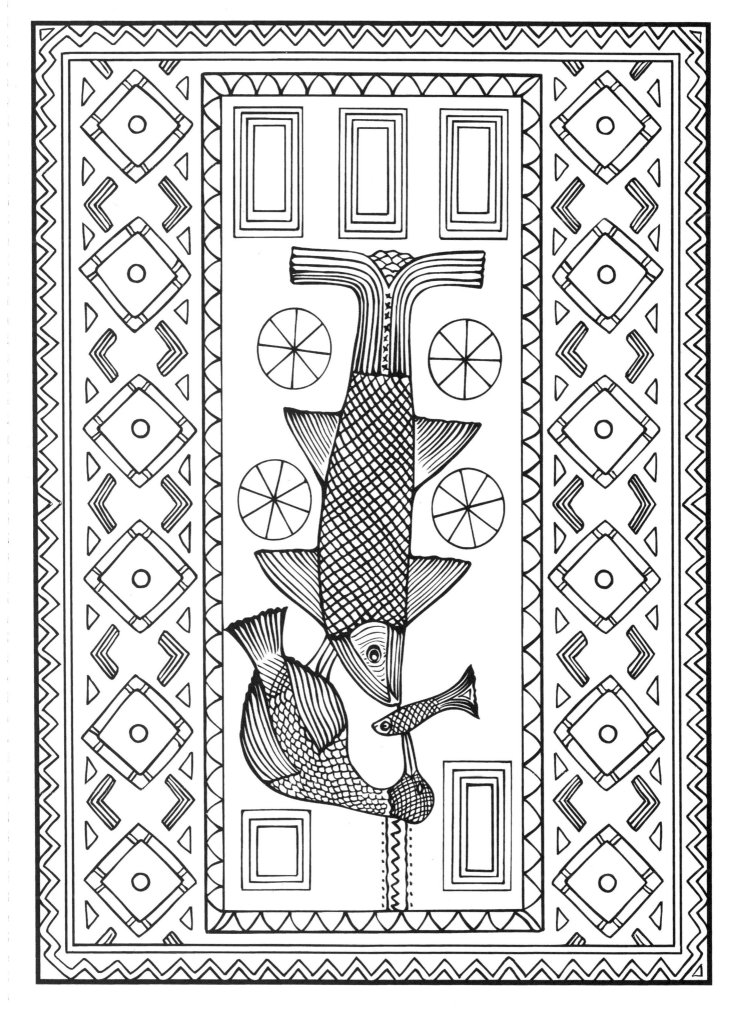

3

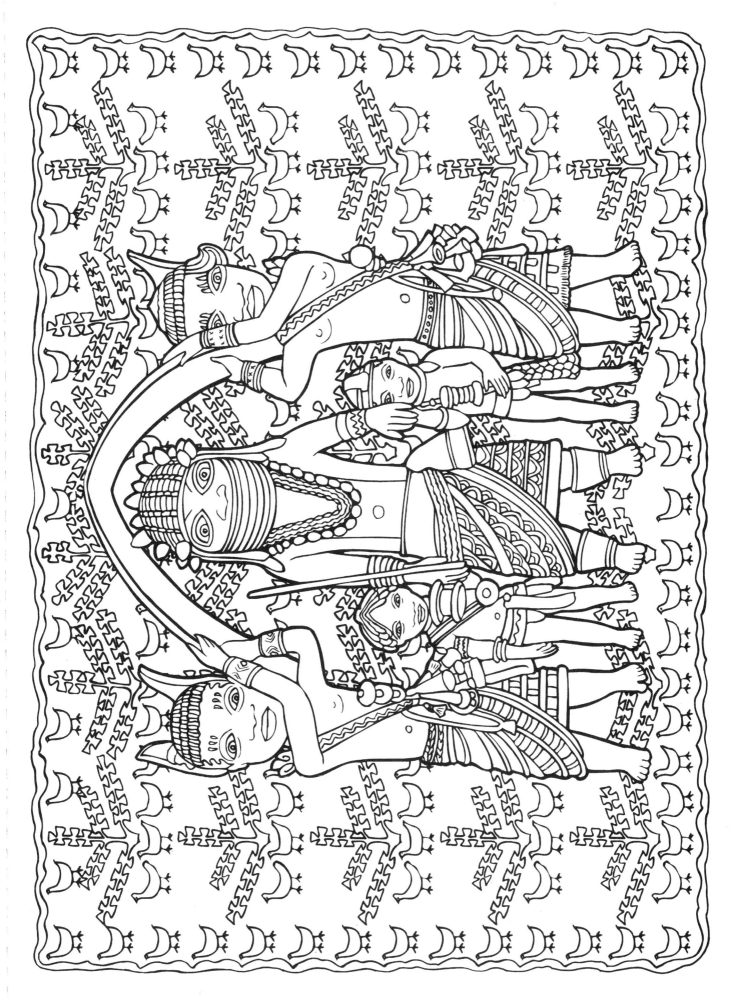

4

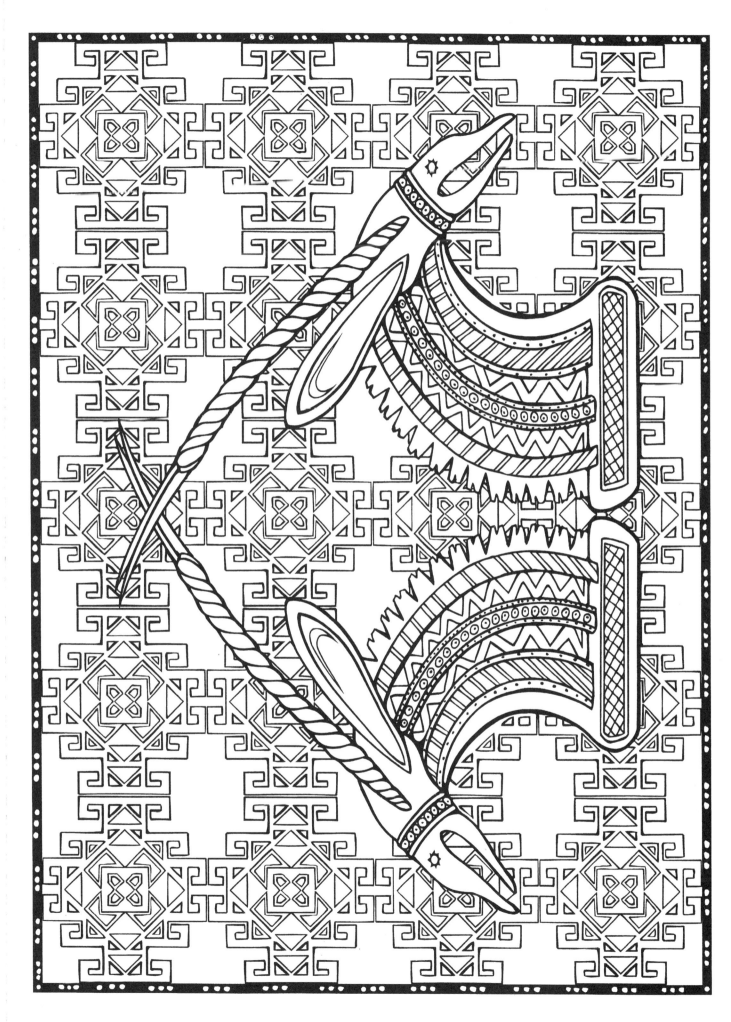

5

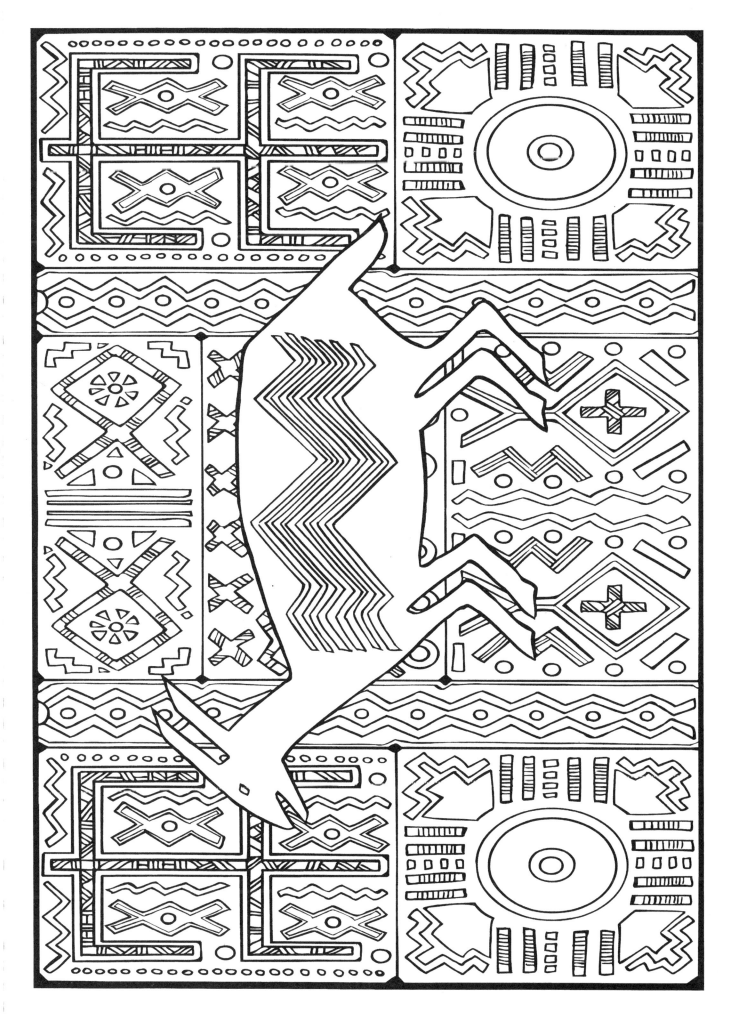

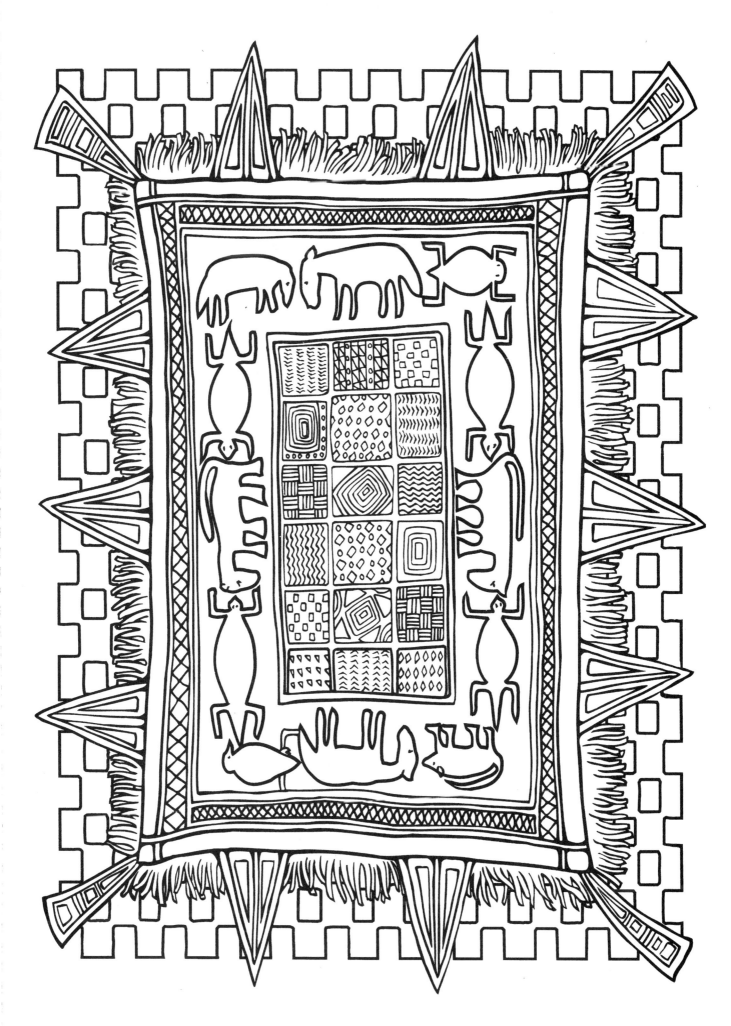

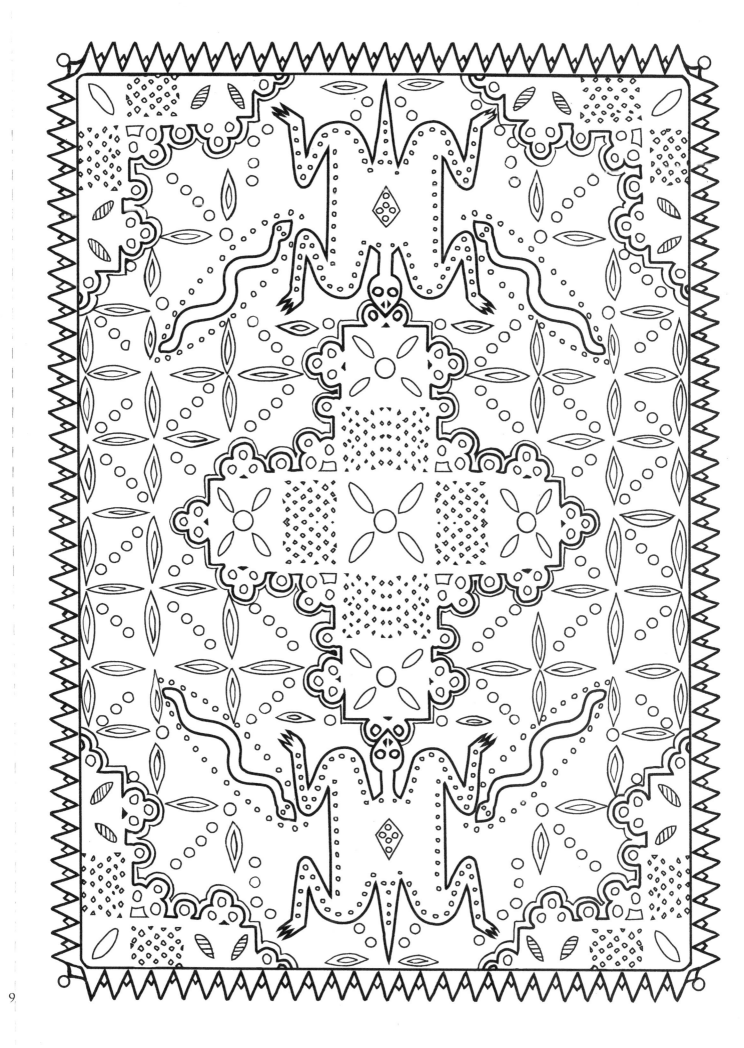

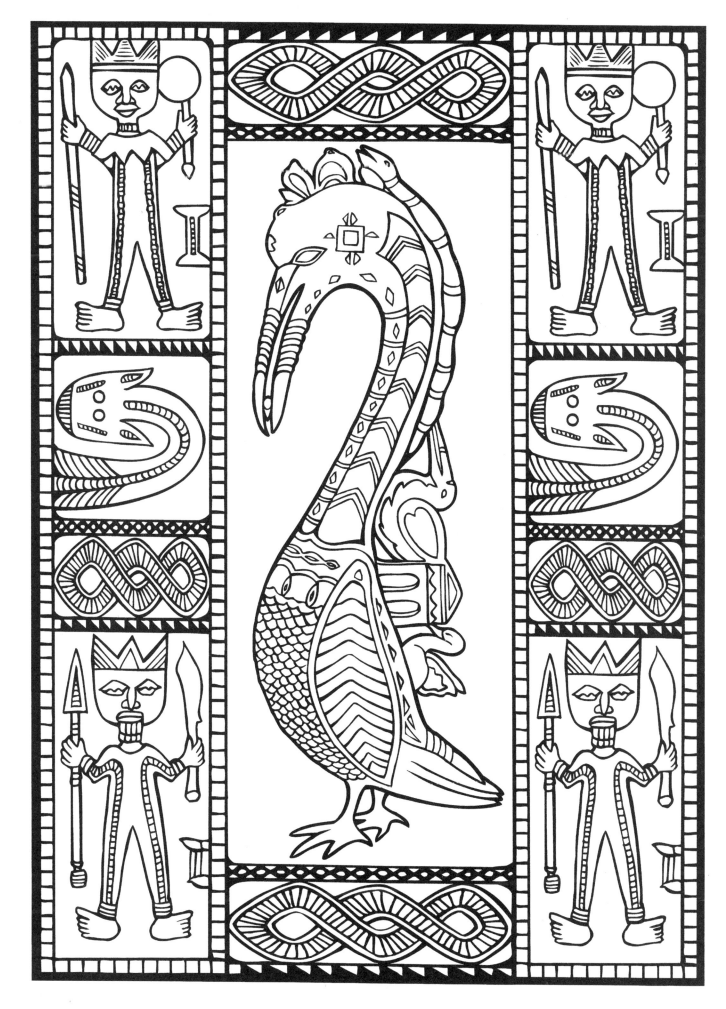

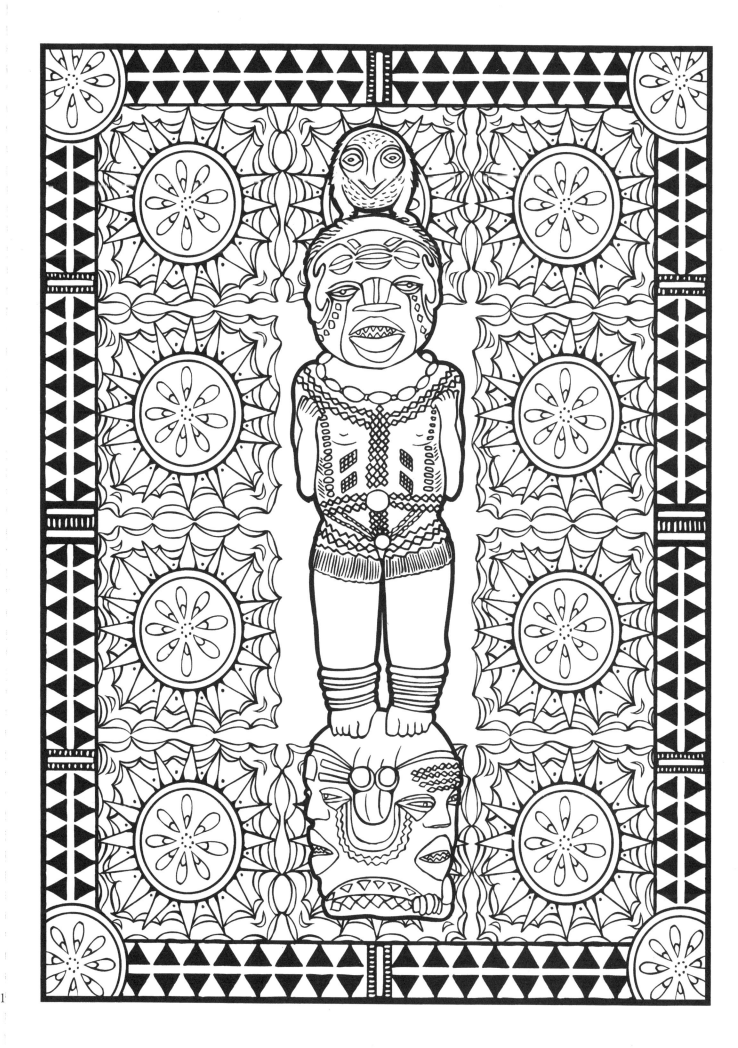

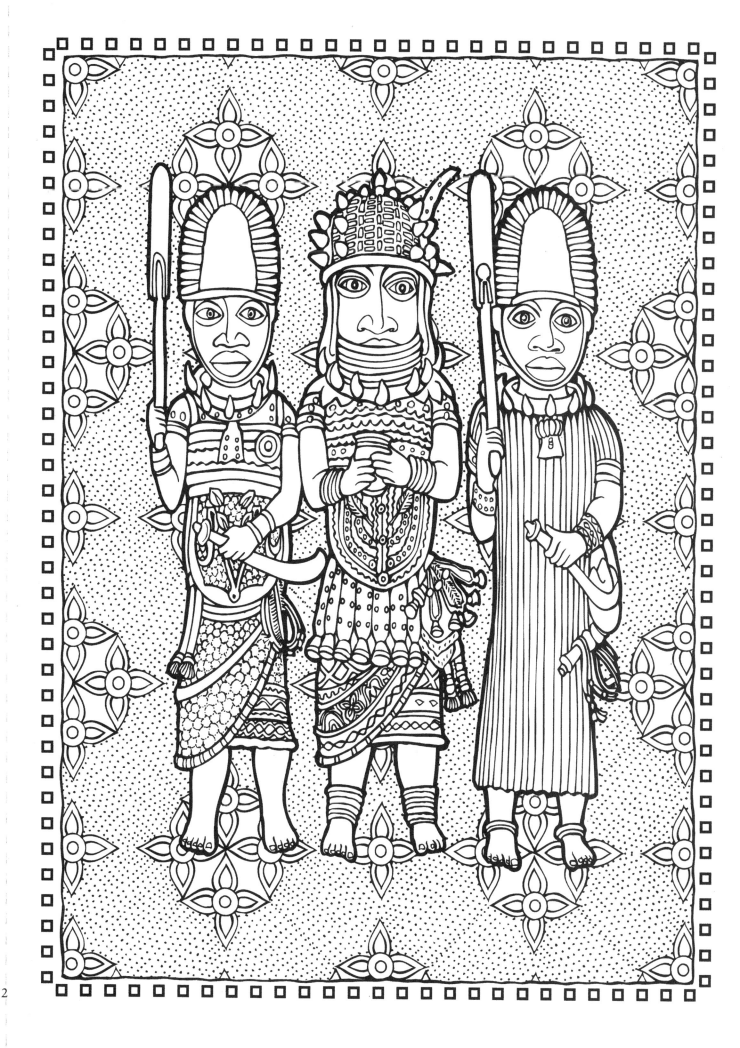

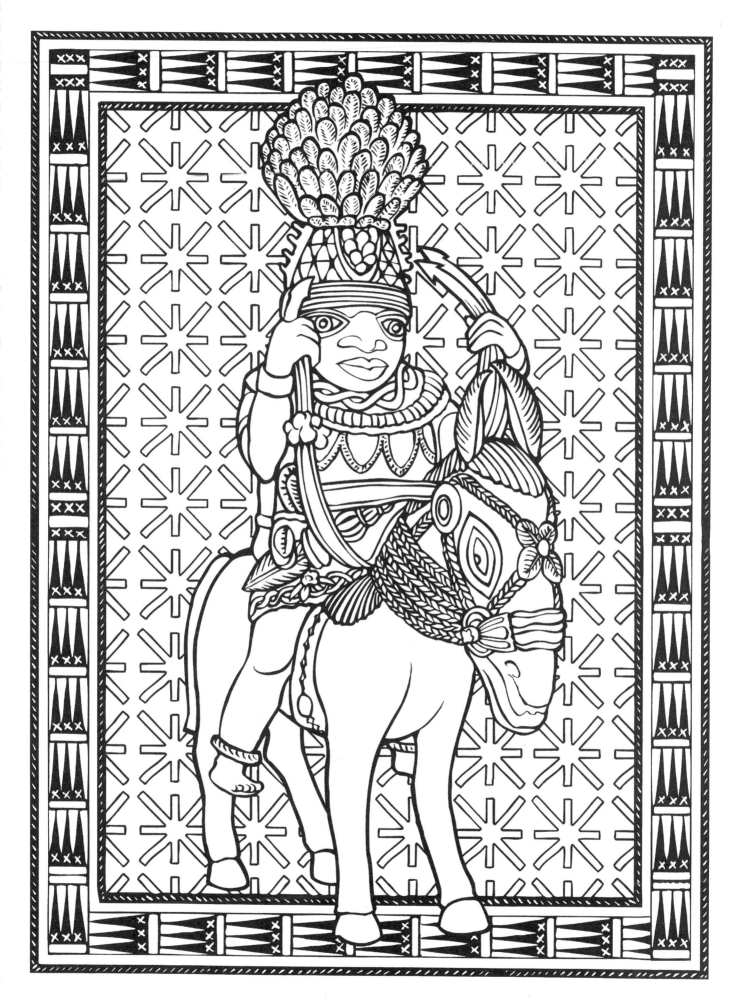

4

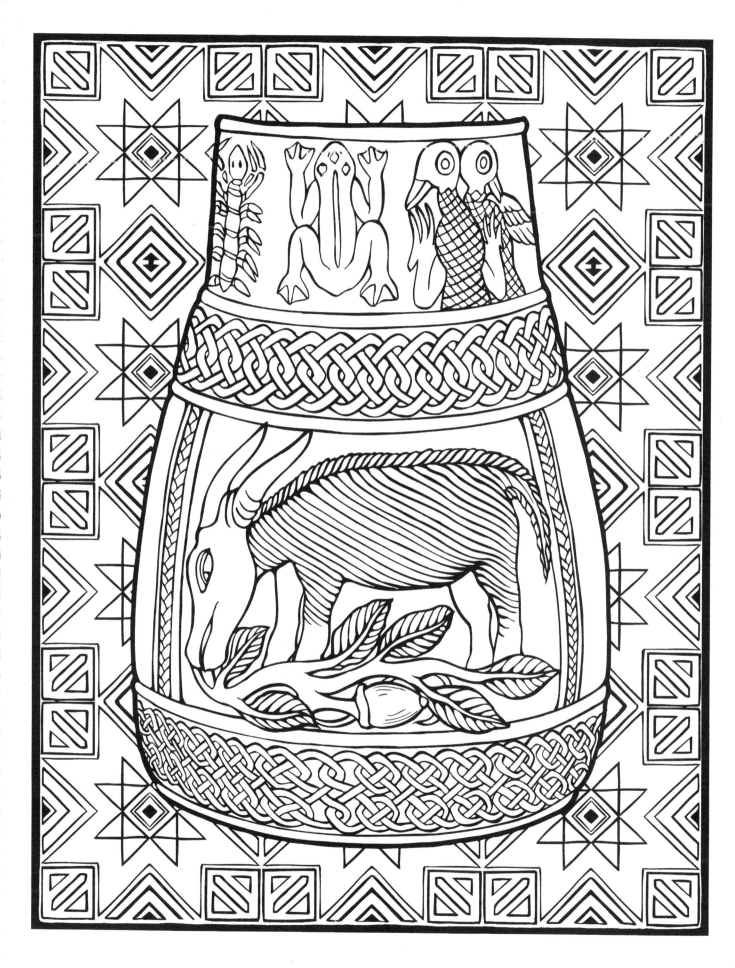

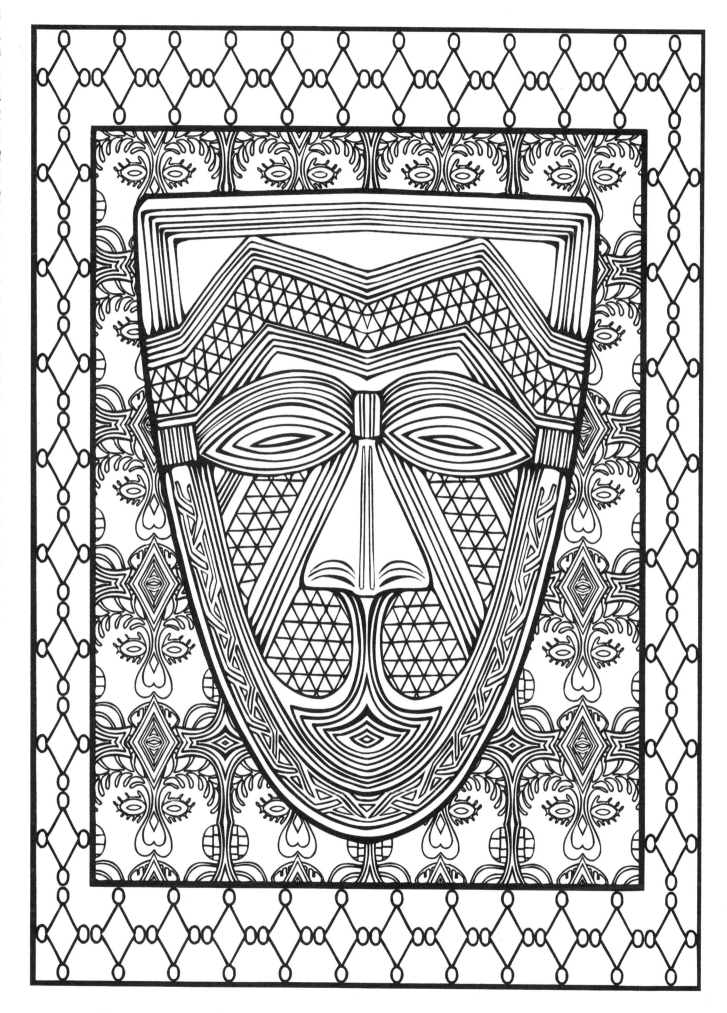

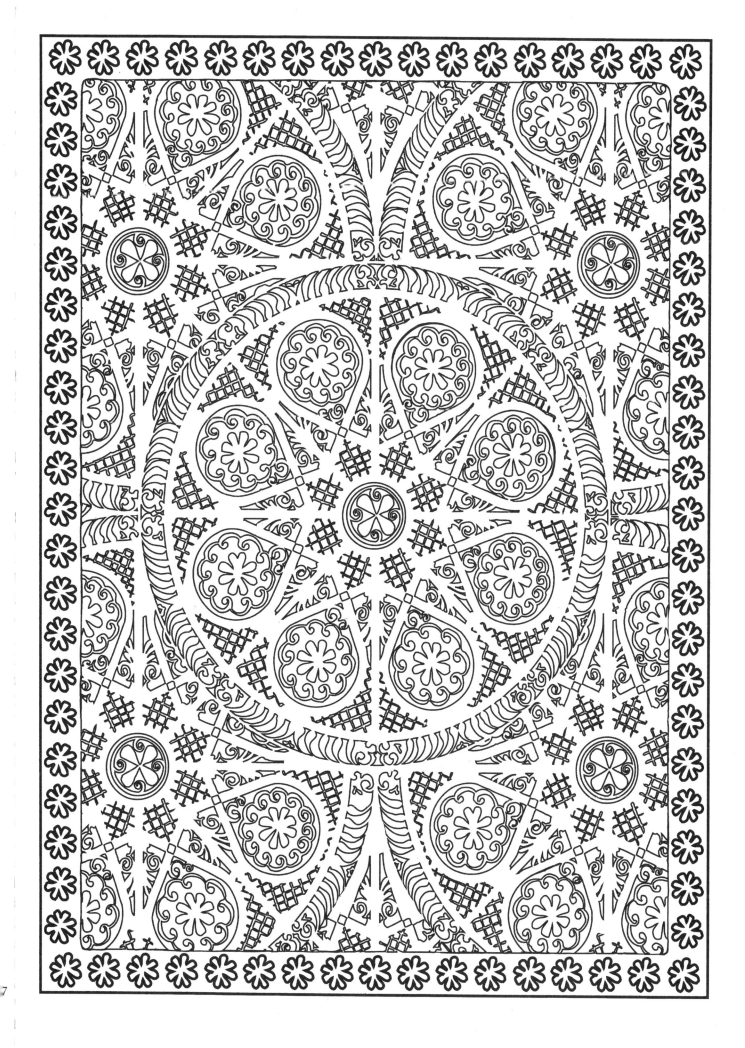

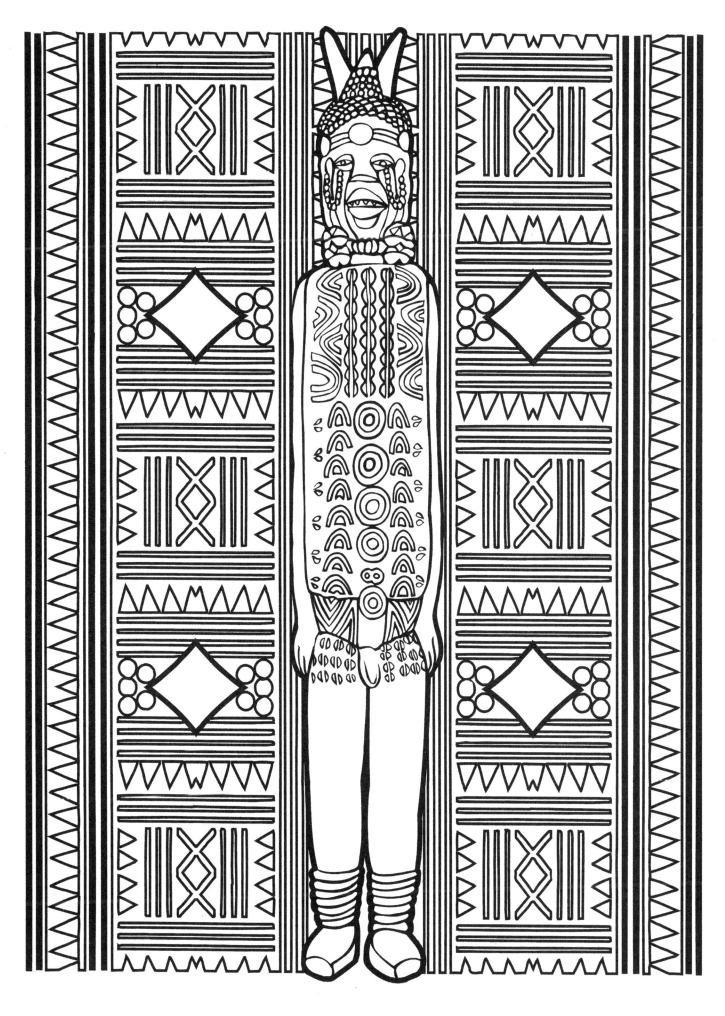

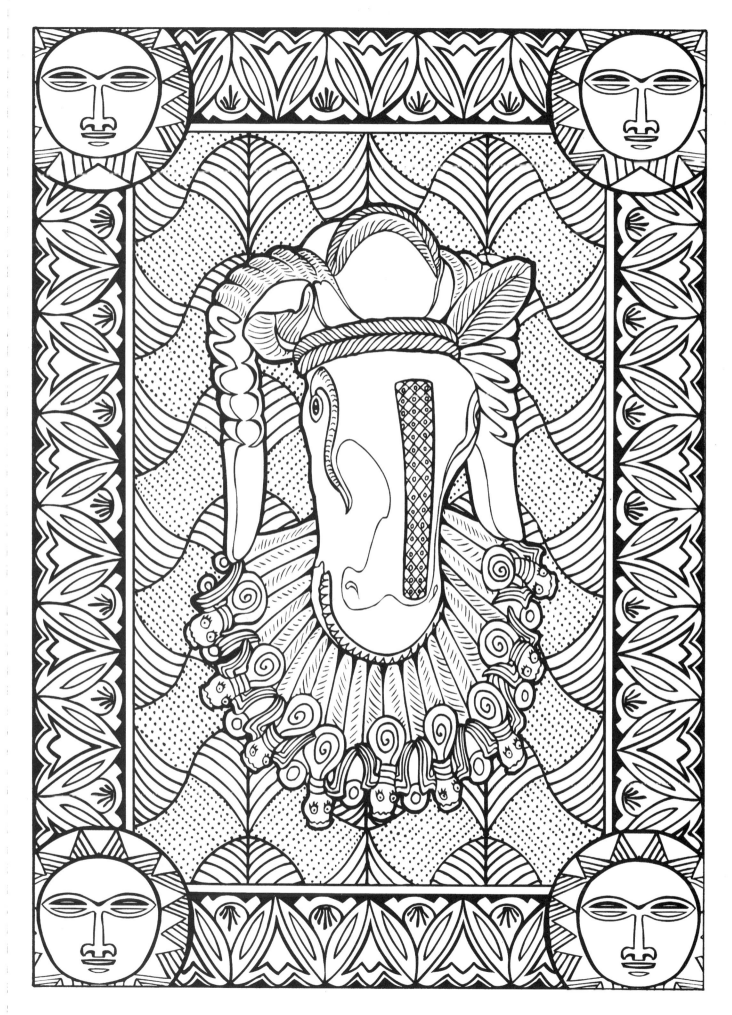

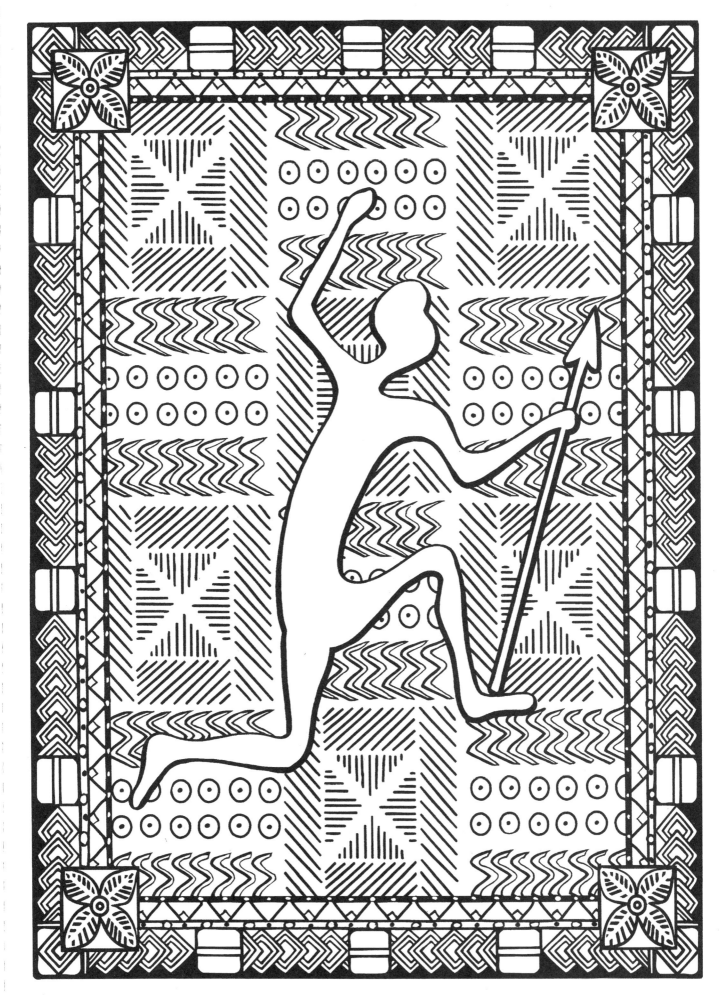

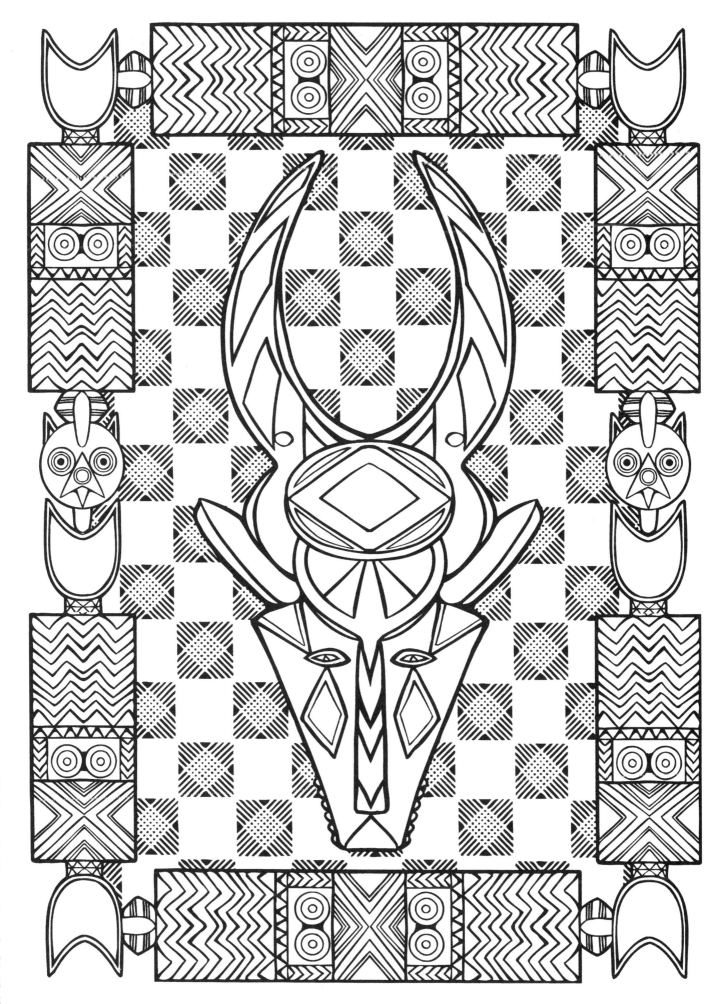

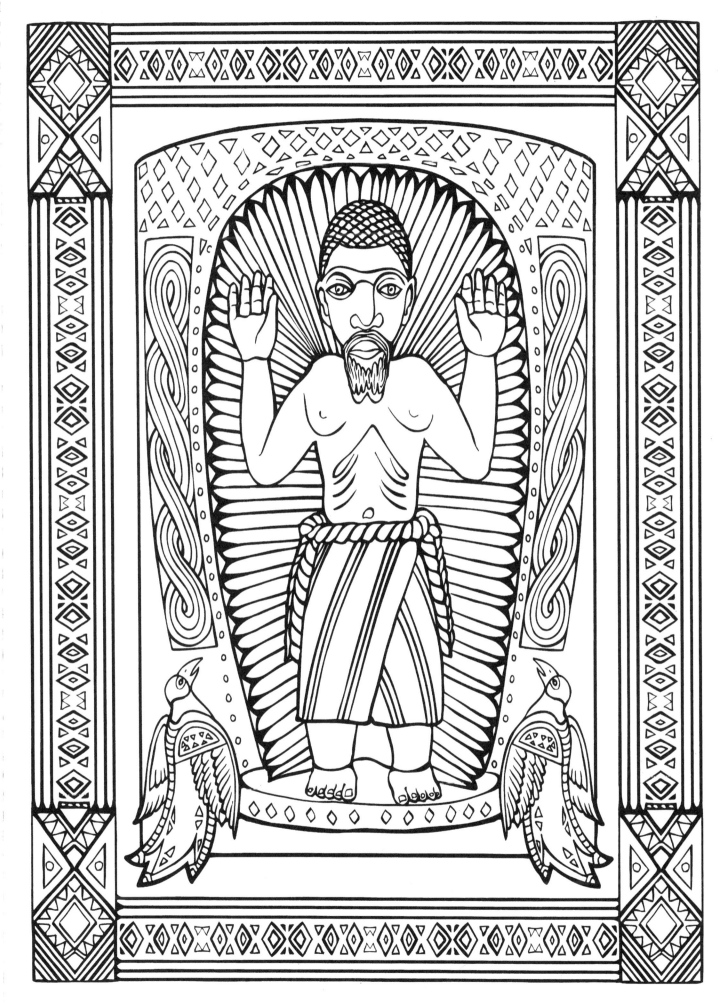

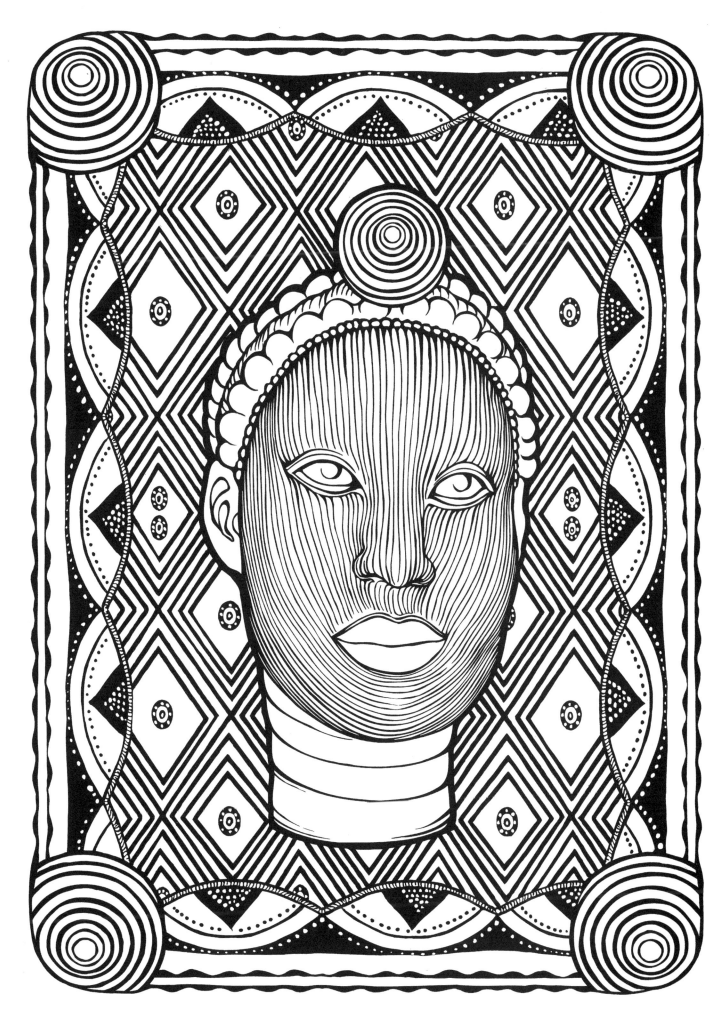

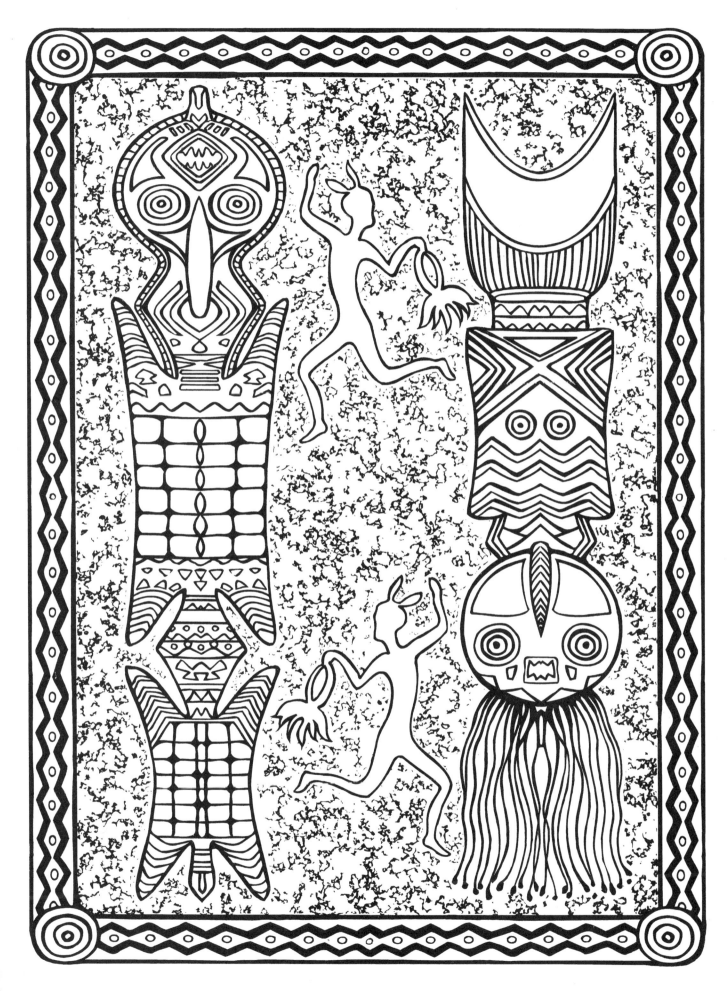

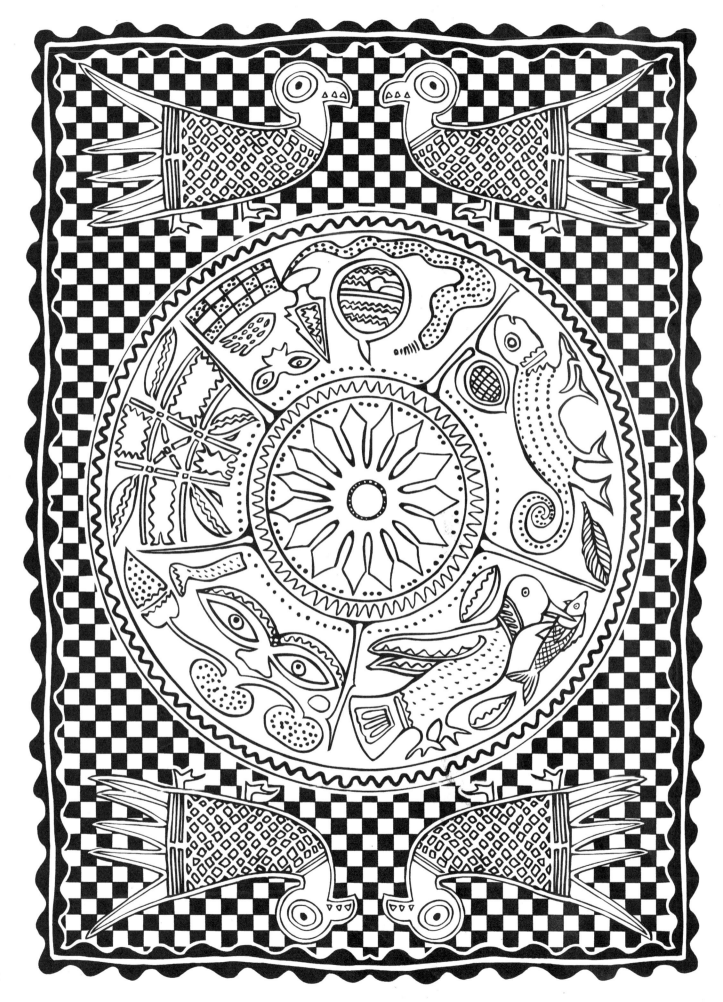

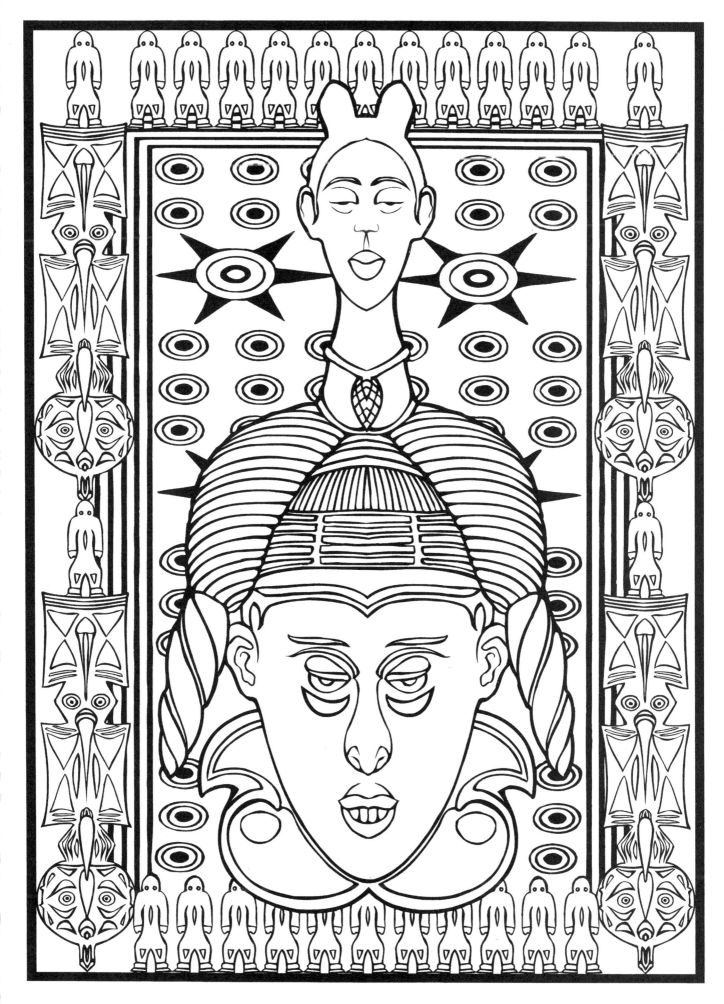

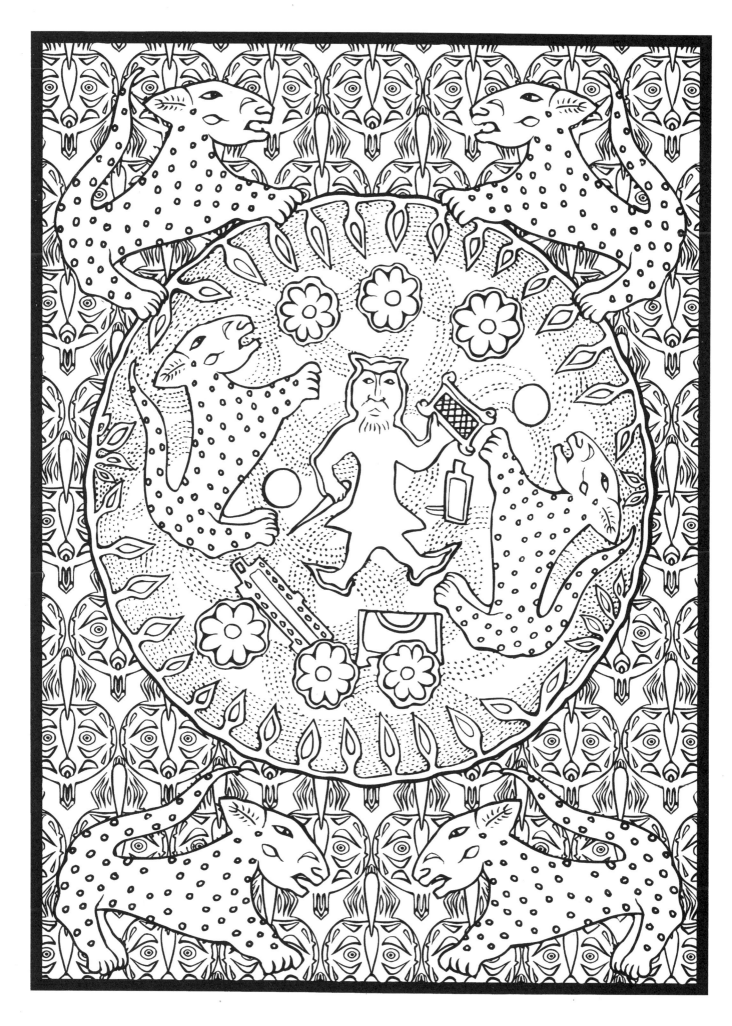

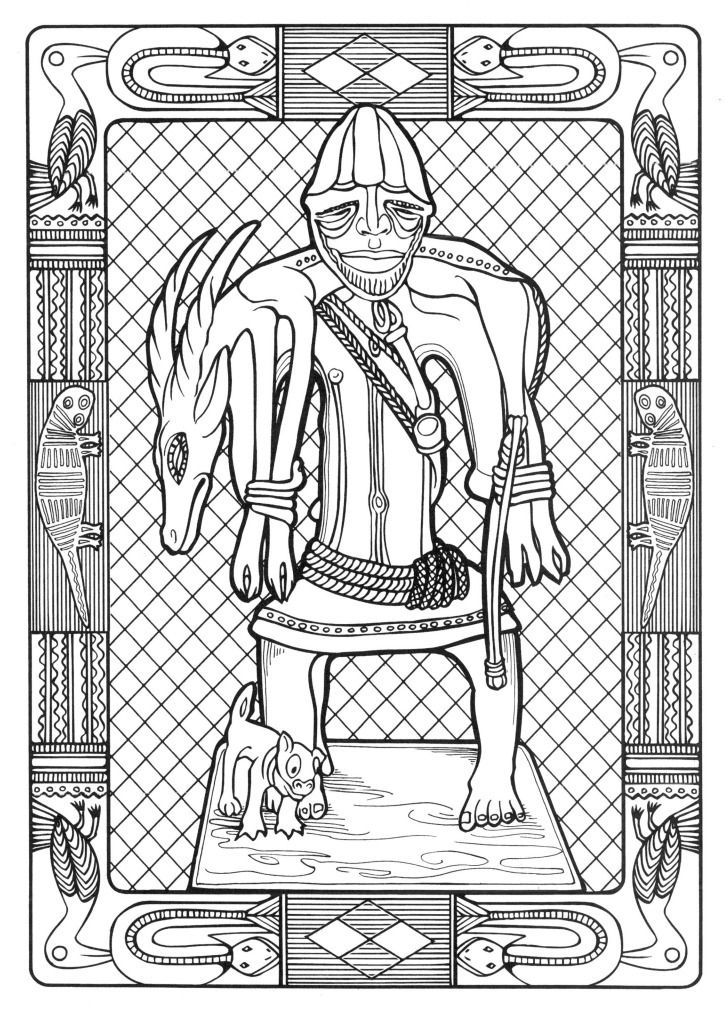

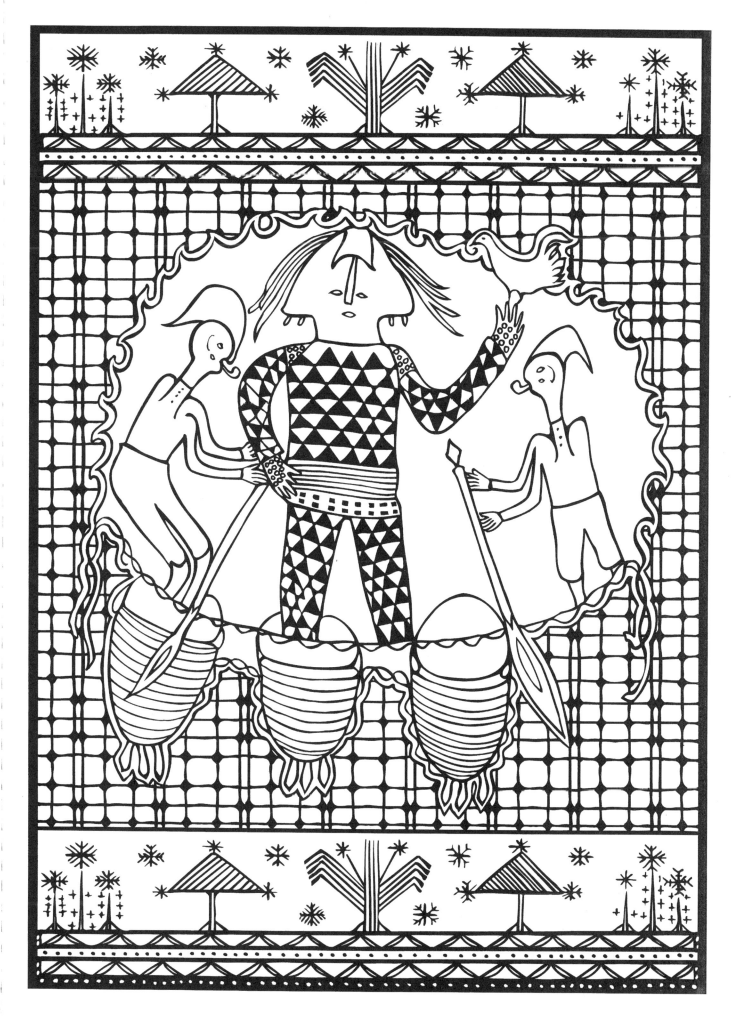

9

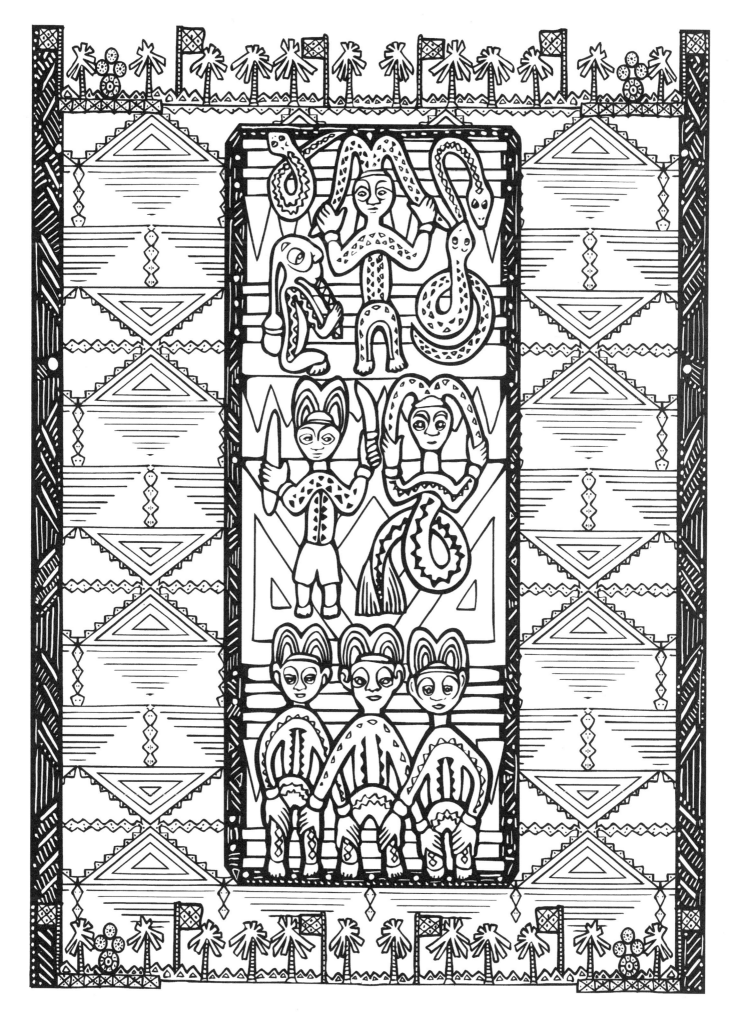

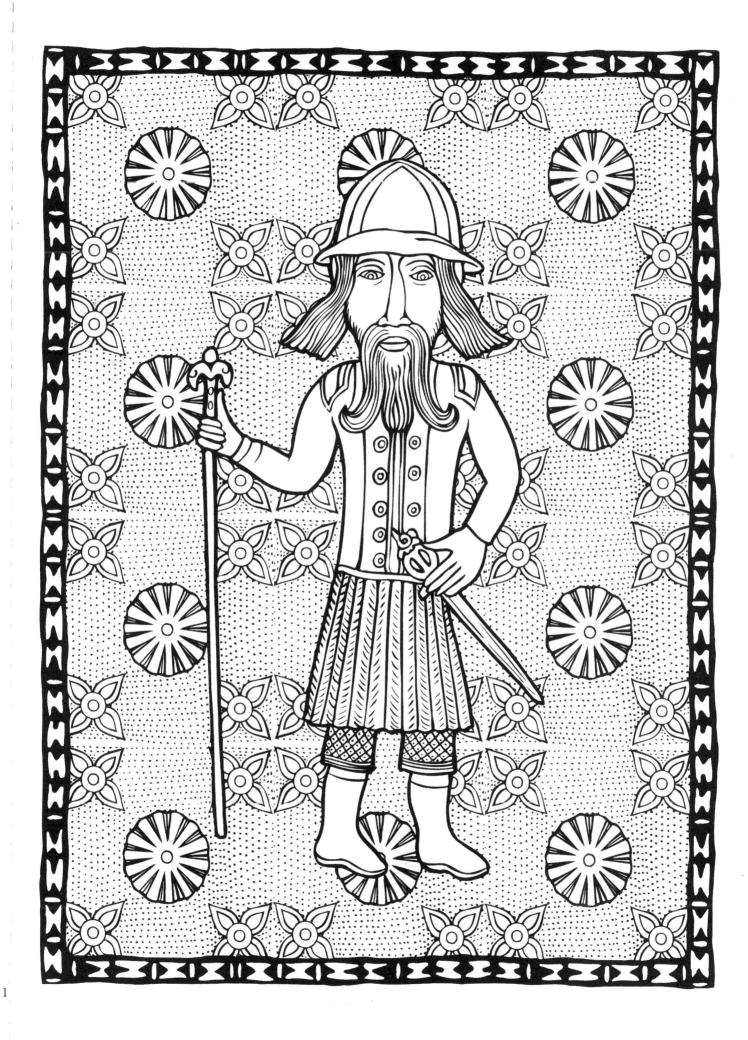